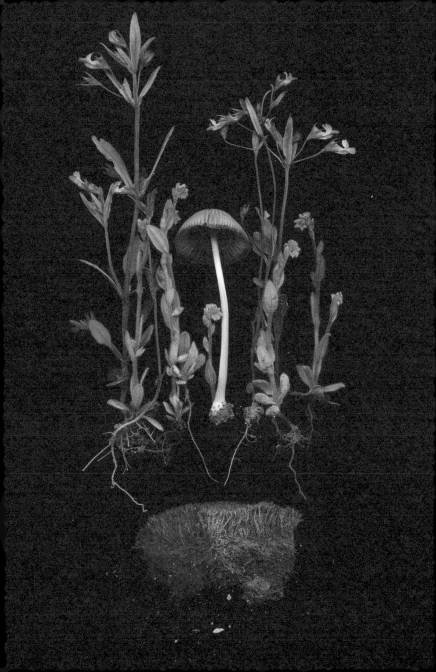

Coprinellus micaceus 1
(mica cap, shiny cap, or glistening
inky cap mushroom)

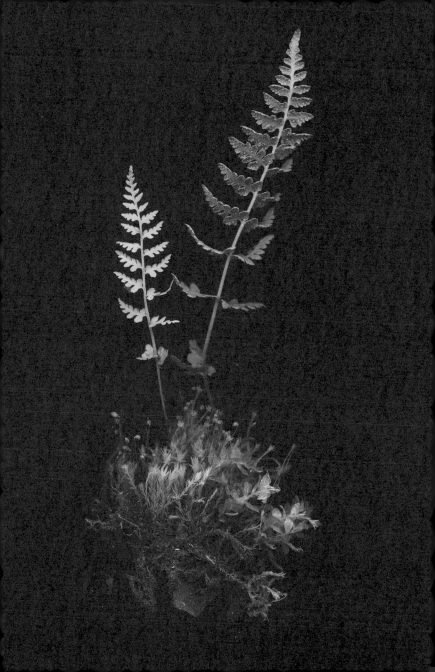

Cystopteris fragilis
(common fragile fern or
brittle bladder-fern)

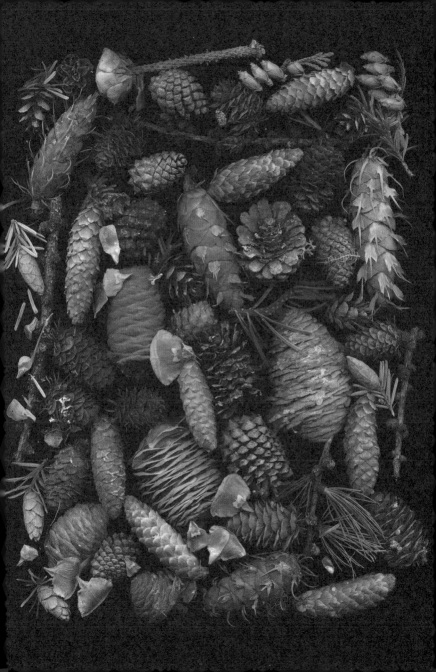

Abies grandis 1
(grand fir)

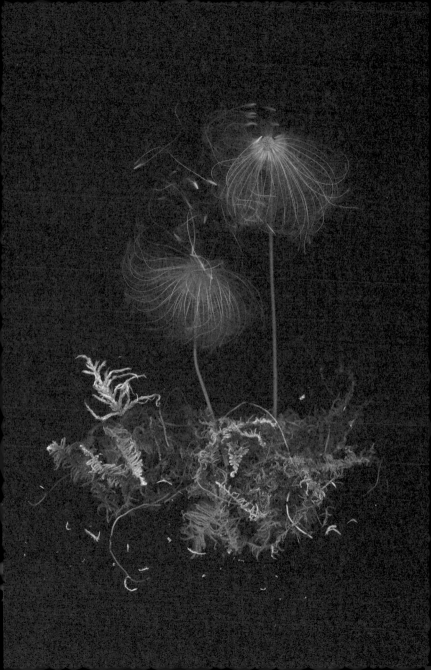

Dryas octopetala
(mountain avens, eightpetal
mountain-avens, white dryas,
or white dryad)

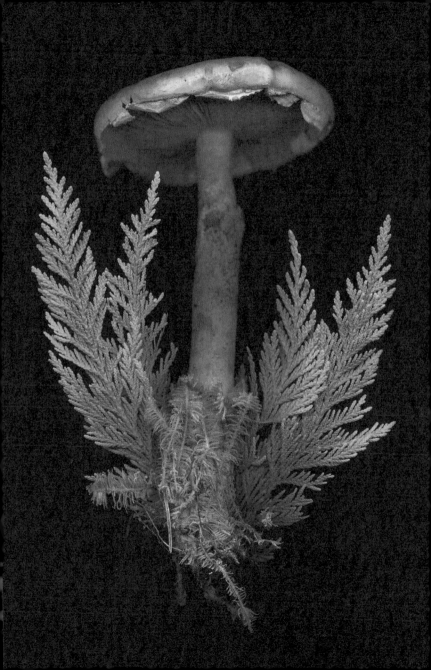

Phaeolepiota aurea
(golden bootleg or
golden cap mushroom)

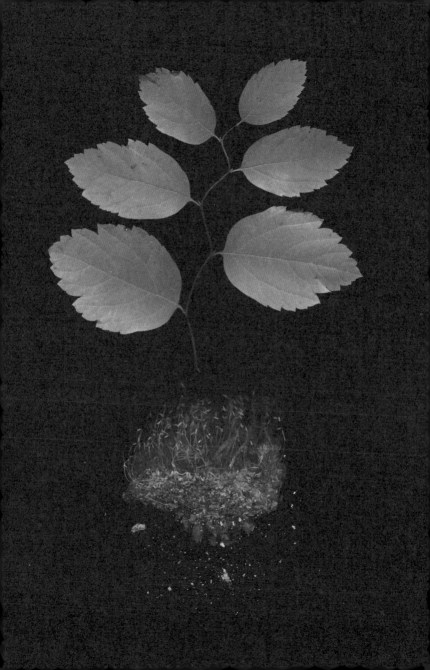

Spiraea betulifolia
(birch-leaved spirea)

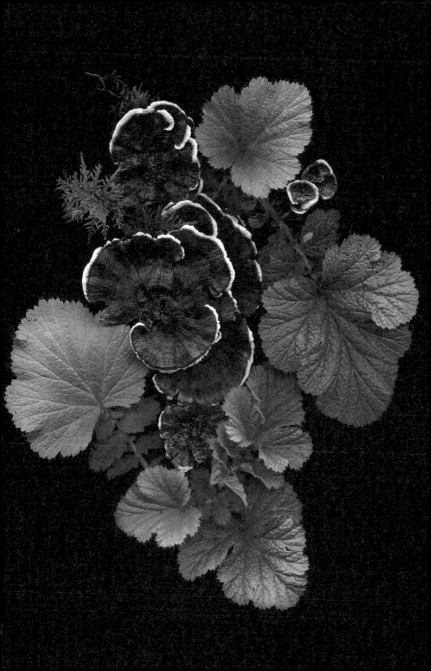

Thelephora terrestris
(common fiber vase or
earthfan fungus)

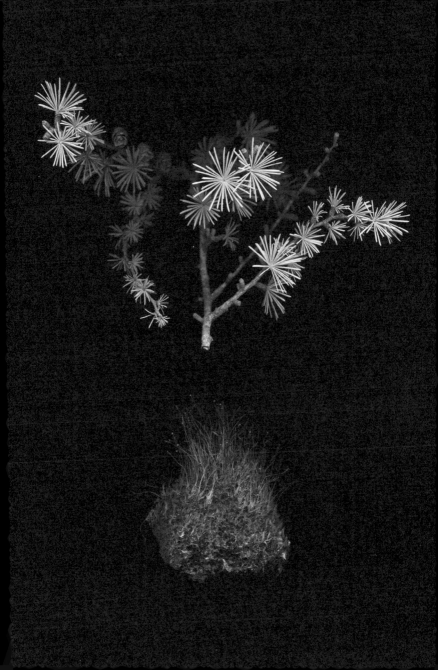

Larix laricina
(tamarack, hackmatack, eastern
larch, black larch, red larch,
or American larch)

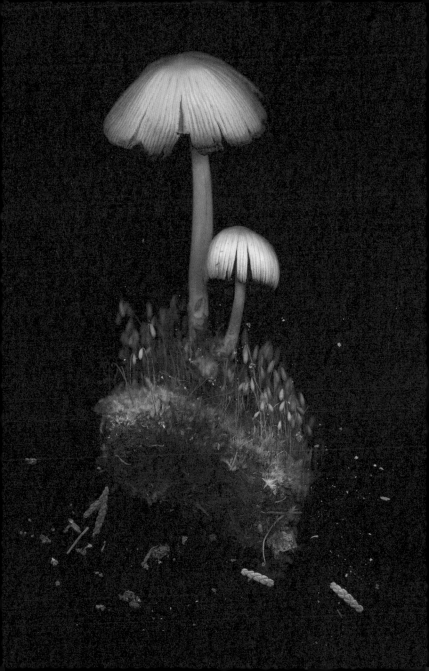

Coprinellus micaceus 3
(mica cap, shiny cap, or glistening
inky cap mushroom)

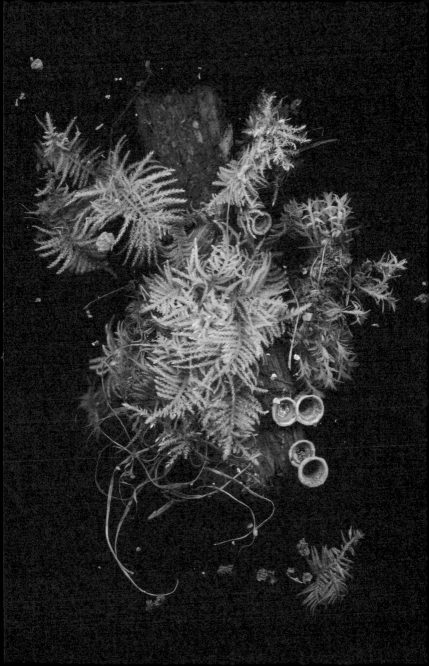

Nidula candida
(bird's nest fungus)

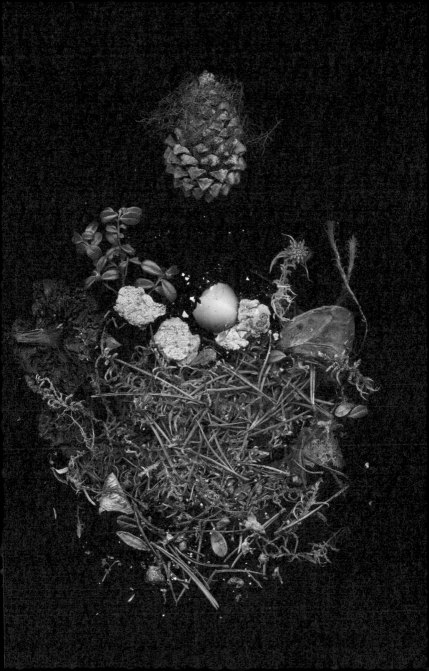

Pinus contorta
(lodgepole pine, shore pine, twisted
pine, or contorta pine)

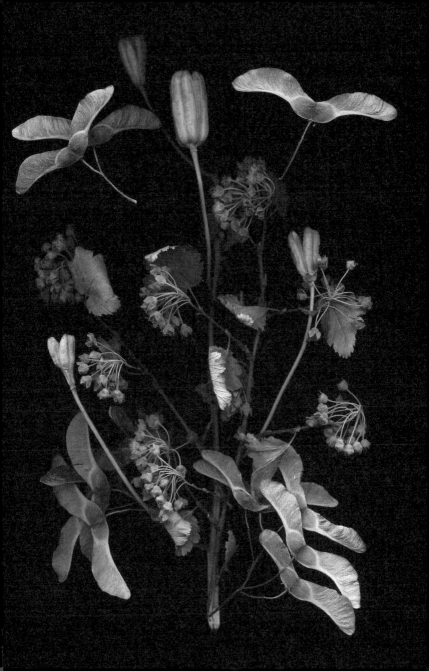

Physocarpus opulifolius
(ninebark, common ninebark, eastern
ninebark, or Atlantic ninebark)

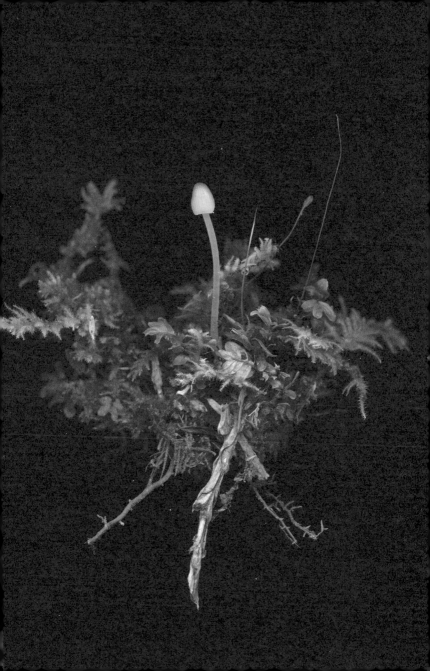

Mycena epipterygia
(yellowleg bonnet mushroom)

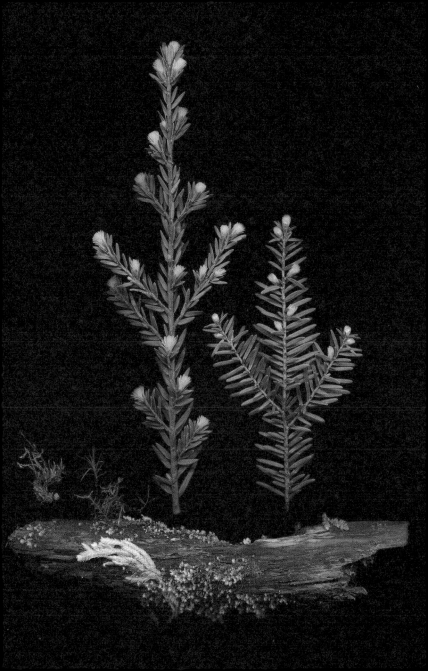

Tsuga heterophylla 3
(western hemlock or
western hemlock-spruce)

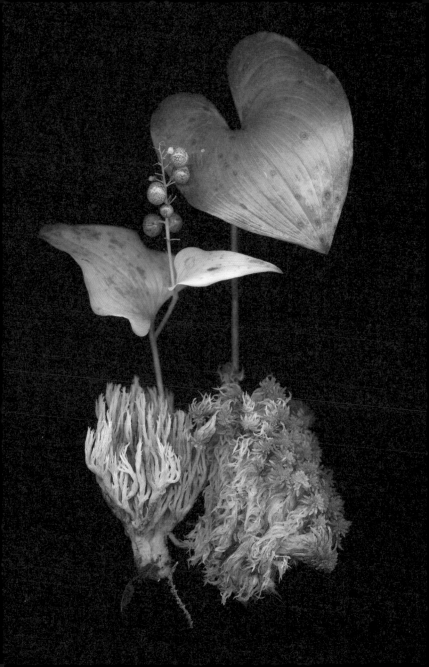

Xylaria hypoxylon
(candlestick fungus, candle
snuff fungus, carbon antlers,
or stag's horn fungus)

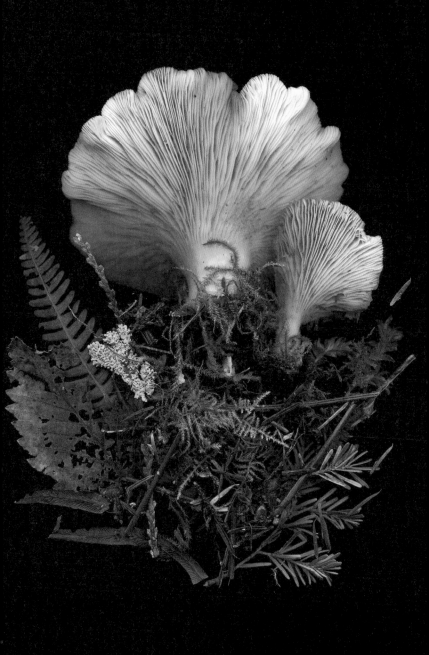

Pleurotus ostreatus
(oyster mushroom, oyster fungus,
or hiratake)

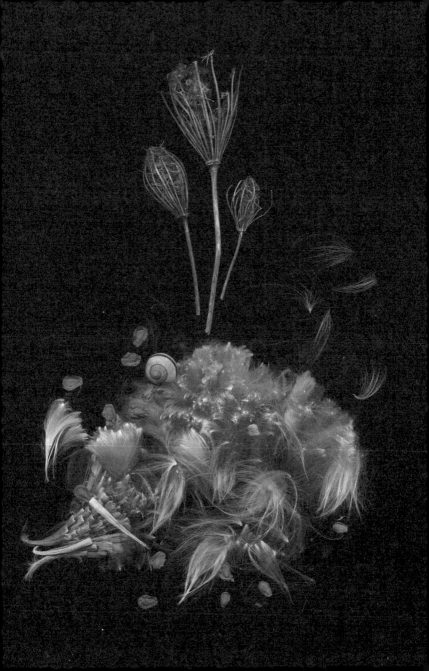

Cepaea nemoralis
(grove snail)

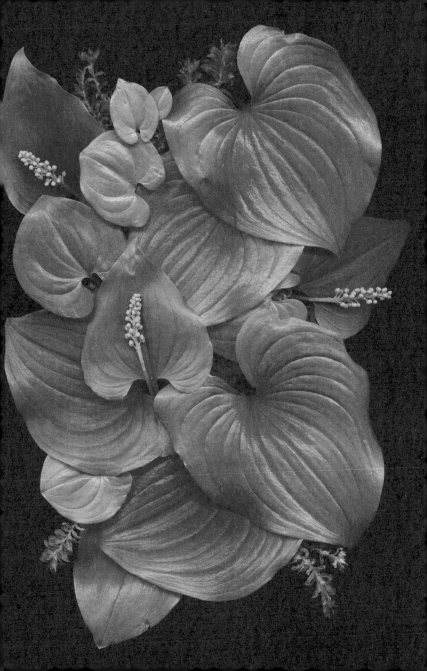

Maianthemum dilatatum
(snake berry, two-leaved Solomon's
seal, or false lily of the valley)

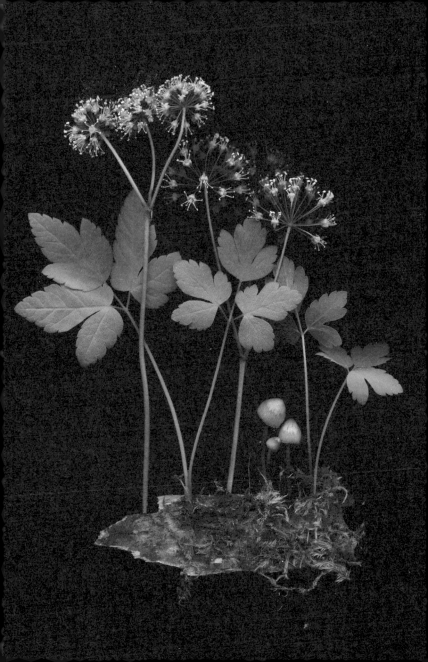

Myrrhis odorata
(cicely, sweet cicely, myrrh, garden
myrrh, or sweet chervil)